A Mother's Love

PAINTINGS BY
Sandra Kuck

TEXT BY
Lisa Guest

Harvest House Publishers
Eugene, Oregon 97402

A Mother's Love

Paintings by Sandra Kuck
Text by Lisa Guest

Copyright © 1998 Harvest House Publishers
Eugene, Oregon 97402

Library of Congress Cataloging-in-Publication Data
Kuck, Sandra, 1947-
 A mother's love : a treasure to be cherished forever / paintings by Sandra Kuck; text by Lisa Guest.
 p. cm.
 ISBN 1-56507-814-4
 1. Kuck, Sandra, 1947- —Themes, motives. 2. Mothers in art. 3. Children in art.
I. Guest, Lisa. II. Title.
ND237. K757A4 1998
759. 13—dc21 97-44463
 CIP

V.F. Fine Arts, Inc.
1737 Stibbens St., #240B
Houston, TX 77043
1-800-648-0405

Design and production by Garborg Design Works, Minneapolis, Minnesota

Scripture quotations are from the Holy Bible, New International Version®. Copyright © 1973, 1978, 1984 by the International Bible Society. Used by permission of Zondervan Publishing House; The Living Bible, Copyright © 1971 owned by assignment by Illinois Regional Bank N.A. (as trustee). Used by permission of Tyndale House Publishers, Inc., Wheaton, Illinois 60189. All rights reserved; the Revised Standard Version of the Bible, Copyright 1946, 1952, 1971 by the Division of Christian Education of the National Council of the Churches of Christ in the U.S.A. Used by permission.

Printed in the United States of America.
98 99 00 01 02 03 04 05 06 07 / WZ / 10 9 8 7 6 5 4 3 2 1

A Child's Thanks

Thank you for

Sharing my dreams

Joining in my adventures

Slowing down to see life through my eyes

Taking delight in all that delights me

Thank you for

Saying no

Setting boundaries

Giving me a home

Providing me a sanctuary

Thank you for loving me in
all these ways and more
Thank you for loving
me always

A Mother's Love

From the moment you gave birth—

if not from the moment of conception—

you've given of yourself in order that I might live.

You give up your body, if not your sleep;

your daily schedule, if not some lifetime plans;

your own desires, if not several real needs as well.

You did that—and you do that—to give me life,

to give me love.

You love with the love that

only a mother can give.

"*Mother*" *means selfless devotion,*

limitless sacrifices,

and love that passes

understanding.

AUTHOR UNKNOWN

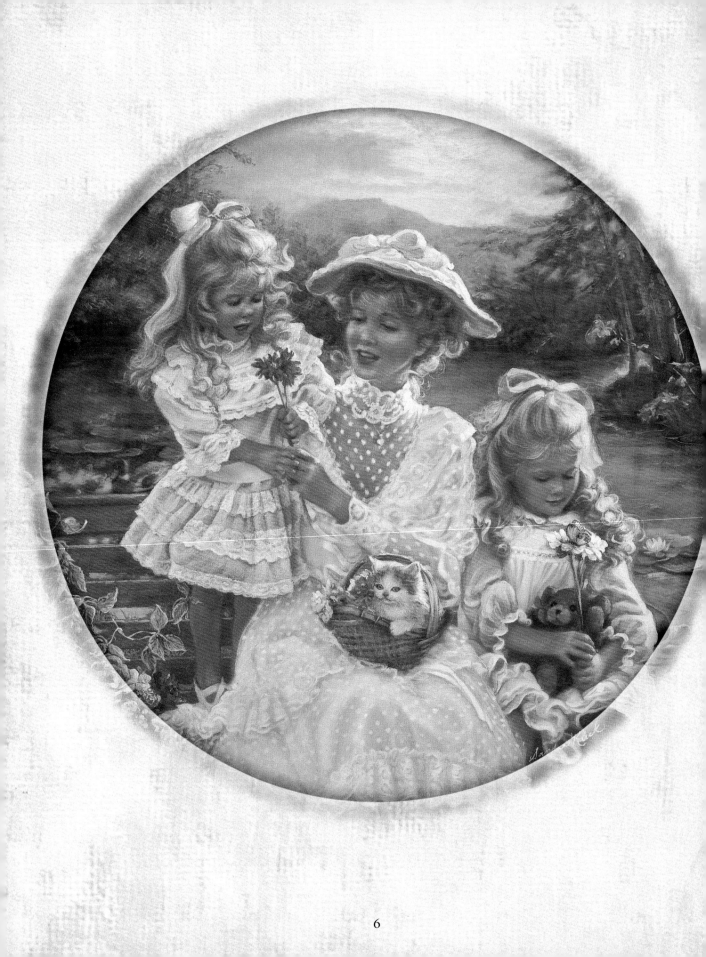

The Children's Blessing

We know such peace in your presence

May you know the peace that comes with recognizing

that what you do is of inestimable value

We rest so secure in your love

May you rest secure in the Source of that love,

that you may always have love to share

We flourish under your caring ways

May you flourish in the confidence that your efforts will

bear the immeasurable fruit of character formed,

of love passed on, of a child become a parent

And may you find joy each day as you mother

Her children stand and bless her . . .

THE BOOK OF PROVERBS

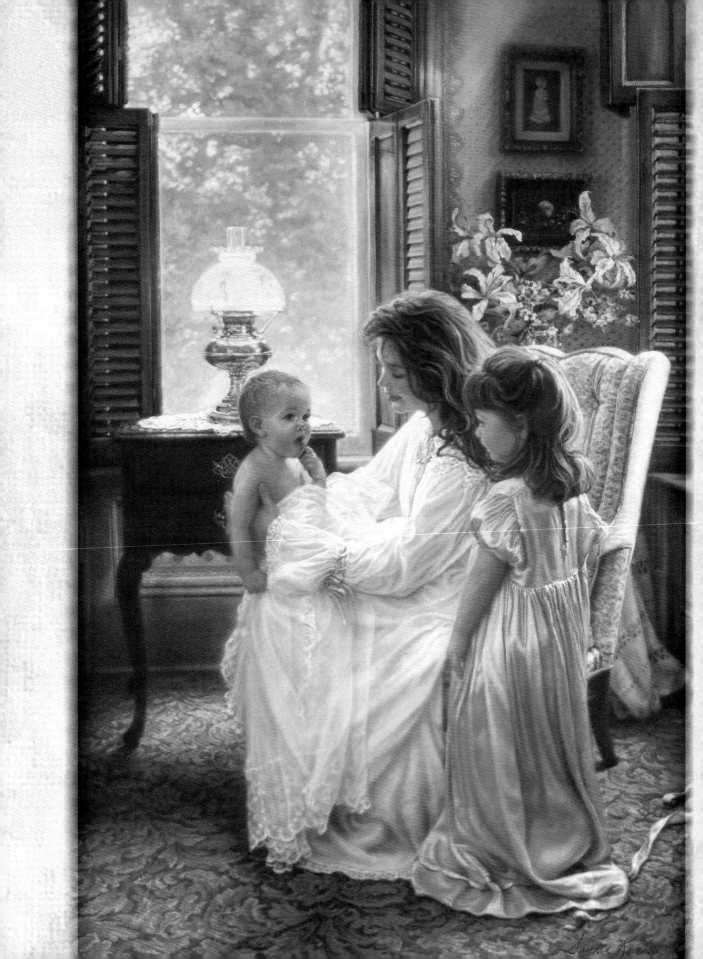

The Miracle of Love

Yours are the eyes that
brighten when you see me,
The hands that hold and
the lap of safety

Yours is the heart that gives love
And teaches love

You're the first introduction
to the gift of family,
to the joy of belonging,
to the miracle of love

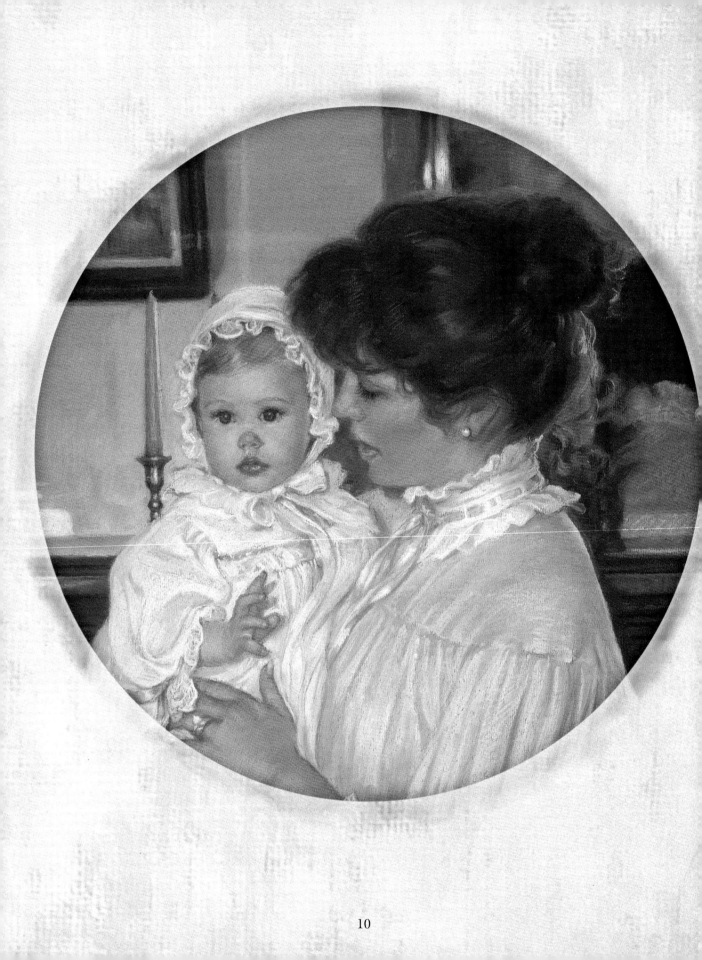

Beyond Words

I may not yet have words, but my love for you is sure

I know the sound of your voice

I know your very smell

I know those eyes of love

I know that voice which soothes

I know that laugh which warms

I know that song which delights

I know that touch which comforts

I may not yet have words, but my love for you is sure

Dear Mommy,

It's sure a big world out there, Mommy! I'm glad I have you!

It's fun to walk away from you at the park—and then come running back to you!

It's good for me to learn to pour my own milk—and have you clean up when I don't stop pouring the milk but the cup stops holding it!

I like choosing my own clothes (all the layers and all the patterns all at once)—and I like having you help me with the buttons.

I like asking for milk and ice cream and bananas—and I like having you share those snacks with me.

Thanks for the trips to the park and the hugs and the stories and the hugs and the tickles and the hugs! I'm glad you're my mommy.

And I'm glad you love me even when I get frustrated and tired and hungry and sad and angry. 'Cause it's a really big world out there, Mommy, and I just don't know what I'd do without you!

Love,
Your Toddler

The First World I Know

Devotion personified
Love embodied

You stare as if I were the only child ever born
You cherish as if no one else had ever given birth
You focus on me, letting me be your world

And, as I grow, you are the first world I know
Providing oceans of love
Mountains of hope
Rivers of peace
Streams of comfort
Solid ground for stability

Devotion personified
Love embodied
The first world I know

*Every mother has the breathtaking privilege of
sharing with God in the creation of new life. She
helps bring into existence a soul that will endure
for all eternity.*

JAMES KELLER

Hands...

Hands...

 That mold Playdoh also mold character

 That spread peanut butter also spread love

 That wipe bottoms also wipe tears

 That provide also protect

 That hold a child also hold a heart

 That fold in prayer also enfold the one prayed for

 in devoted care and continual blessing

The hands by which God provides for a child....

The hands of a mother

I shall never forget my mother, for it was

she who planted and nurtured the first seeds of

good within me. She opened my heart to the

impressions of nature; she awakened

my understanding and extended my horizon,

and her precepts exerted an everlasting influence

upon the course of my life.

IMMANUEL KANT

Speaking the Same Language

It's gibberish to an outsider...
Context clues are everything...
A single sound means many things...
 Some words are created for the
 moment...
A specialized vocabulary...
 Missing letters...
 Added syllables...

It's all music to the ears of a mother
As the child she loves begins to speak
As she gets to know a little better
 this little person she brought into the
 world

After all, they're speaking the same language—
 A language of love

A mother understands what a child does not say.

JEWISH PROVERB

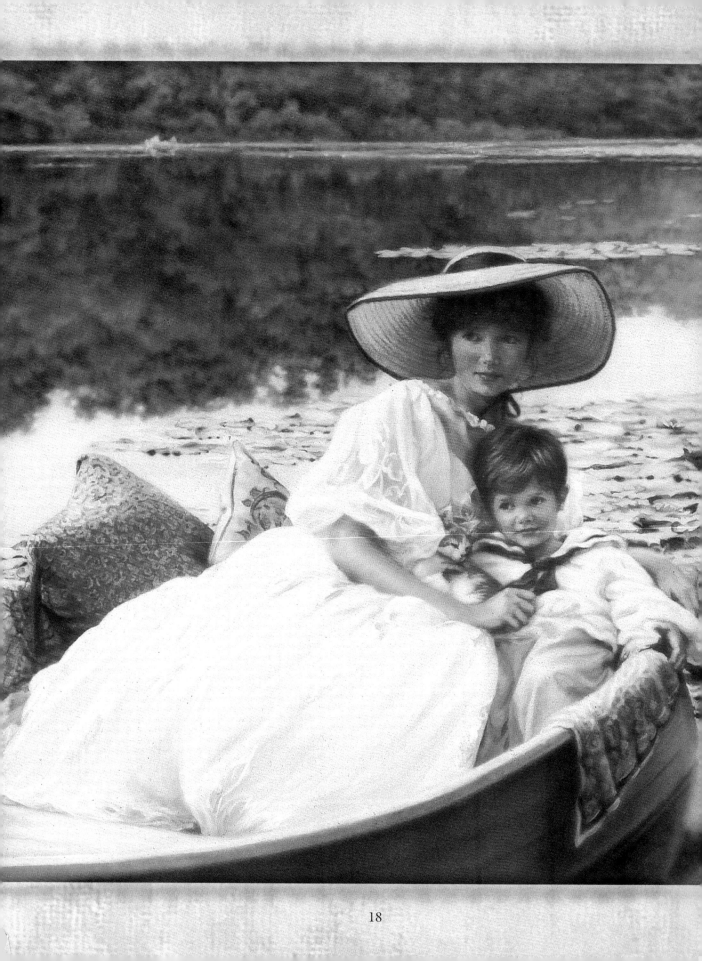

Your Very Presence

Your voice brings peace

Your touch means comfort

Your very presence is love

Since the beginning you were there

Caring for me, providing for me

Protecting me, loving me

It's therefore no surprise that

Your voice brings peace

Your touch means comfort

Your very presence is love

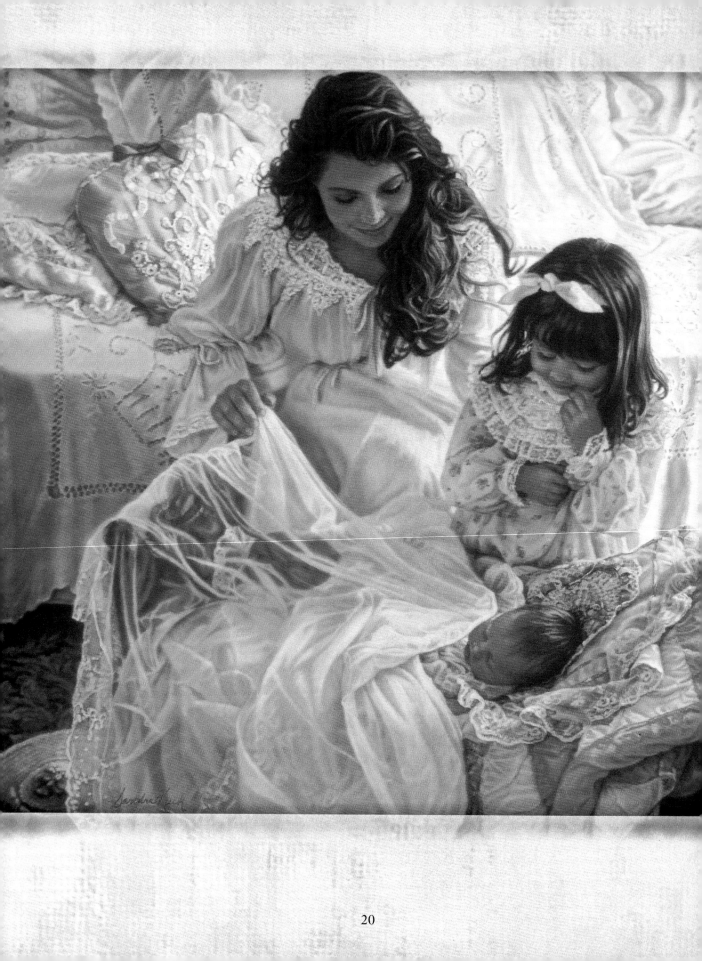

A Maternal Mystery

A mother's love is always able to enfold another child
without at all depleting her love for the others

Your heart readily embraces a new little life
even as you continue providing all that the family needs

And as you do so, your love empowers the older
to love the younger
blessing the older with a sense of her important position
blessing the younger with a sibling's love

And being blessed by the circle of love
by the widening circle of deepening love

A Love That Never Lets Go

The fierce love of a mother tiger

It is passionate and protective

Energetic and focused

It may come at the moment of birth

It often comes with an unexpected power

and lasts with unhindered intensity

It's the love of a mother,

a love that never lets go

Dear Mom,

In case I don't tell you, Mom, it's great that you're my mom! I mean, who else cares as much about what's going on in my life?

I never knew you'd care about the main industries of Lebanon . . . or that you'd be able to help me so much with my science project on recycling. And it's great to have you help me practice my spelling words and listen to my oral book report before I have to stand up in front of the class (I hate that!).

And, even with all the other things you have to do, you go to my soccer games, and you always make the cupcakes even when I forget to tell you until the night before! And it's cool to have you help in my classroom one morning a week! And thanks for doing the Scouts thing with me!

And, oh, yeah, I love you—even when I get too busy to tell you! So keep tucking me into bed at night, okay? I know I'm not four anymore, but I still need hugs from my good ol' mom!

Love,
Your Grade-School Child

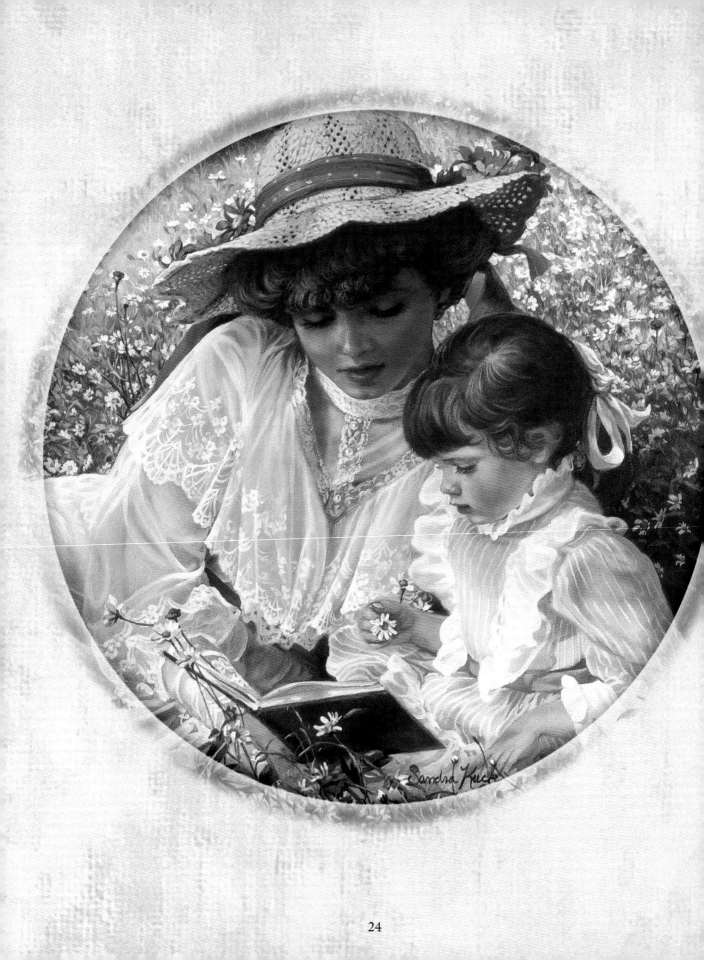

Little by Little

The single page
The books we enjoy

The lone petal
The flowers we gather

The solitary day
The childhood we share

The parts are not to be overlooked
But the impact comes with the whole

And through the whole of my childhood—
In the minute by minute, the day by day—
You have loved me in tiny, daily ways
The impact comes gradually
But it also comes powerfully:
The childhood of books, flowers,
and days that we shared

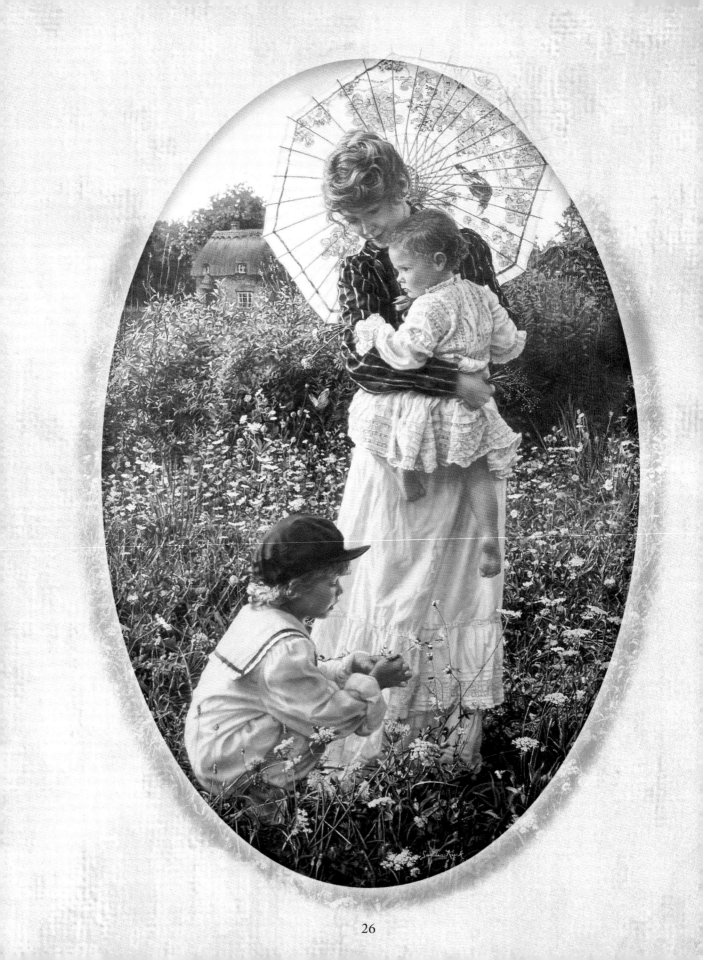

A Mother's Tools

What a juggling act of hearts and schedules,

of desires and needs mothering is!

An extra pair of hands

Another set of eyes

An additional lap available when needed

A spare pair of arms when a hug is essential

A few more hours in the day, if not another day in the week—

These would be helpful.

The only tool big enough, adequate enough,

in a mother's collection is her heart.

The goodness of a home is not dependent

on wealth, or spaciousness, or beauty, or luxury.

Everything depends on the Mother.

G.W.E. RUSSELL

In (A Mother's) Love

Inexplicable in its beginning
and its intensity

Indestructible in its strength
and its tenacity

Incomprehensible in its power
and its limitlessness

Incredible in its giving
and its cost

Infinite through time
Invincible in trials
Inexhaustible…indescribable…invaluable

It's wonderful to find oneself in a mother's love

*Love… always protects, always trusts, always
hopes, always perseveres. Love never fails.*
THE BOOK OF 1 CORINTHIANS

Just How Many?

Just how many not-quite-soccer games can a mother of a
not-quite-five year old watch?
And how many clankety piano recitals and stumbling dance
performances
> Clumsy T-ball practices and toddler birthday parties

> > *Can a mother attend?*

And how many sleepovers in the downstairs living room
> How many decibels from the upstairs bedroom
And how many nights lying awake until the front door opens and closes and
the porch light goes off

> > *Can a mother endure?*

And how many brother-sister battles can a mother referee?
How many "I told you so's" can a mother not speak?
How many heartaches can a mother suffer as she watches her child navigate
through life?

A mother can't answer these questions.
> A mother doesn't count.

> > *A mother loves.*

Life Source

Journeys of the imagination we take together

Books you read until you memorize them

Words you teach me to decipher

Ideas you help me understand

Decisions you help me make

Choices you empower me to live

Dreams you encourage me to pursue

 Life you gave me in the beginning

 Life you enable me to live

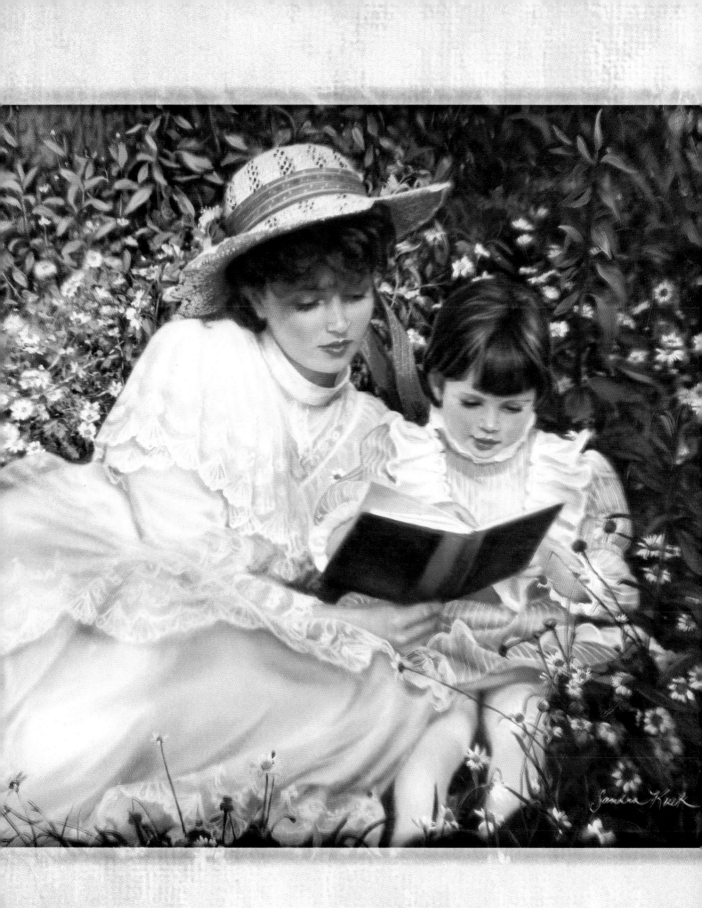

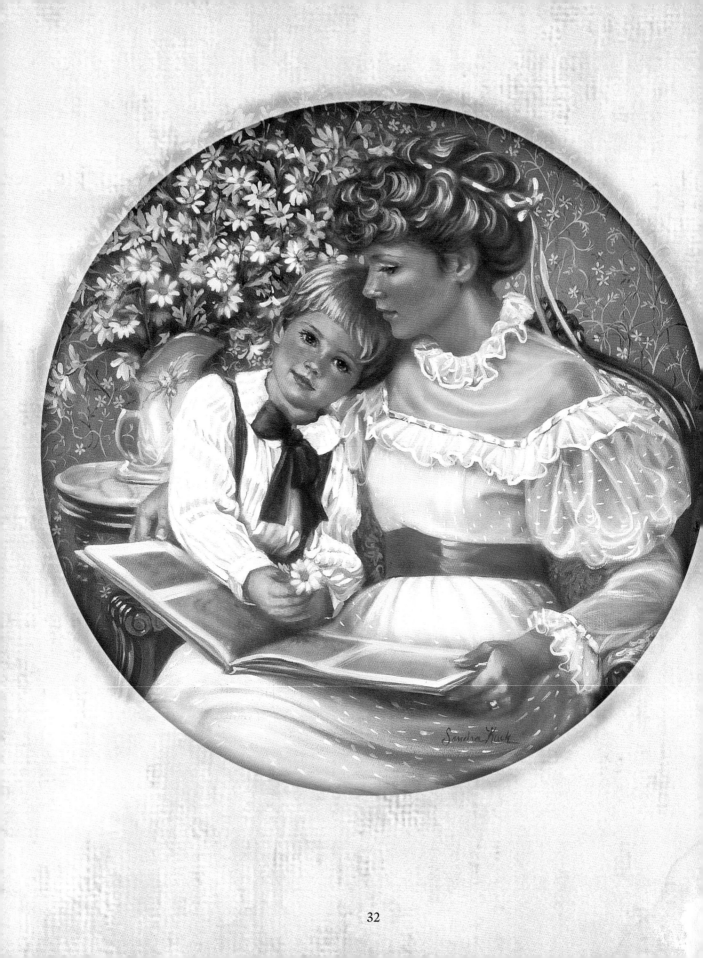

For Your Child

You're a source of quiet prayers
A fountain of hidden hopes

You're a safe haven
A place of rest

You're one who empowers
Who enables dreams to take flight

Youth fades; love droops;
the leaves of friendship fall.
A mother's secret hope
outlives them all.

OLIVER WENDELL HOLMES

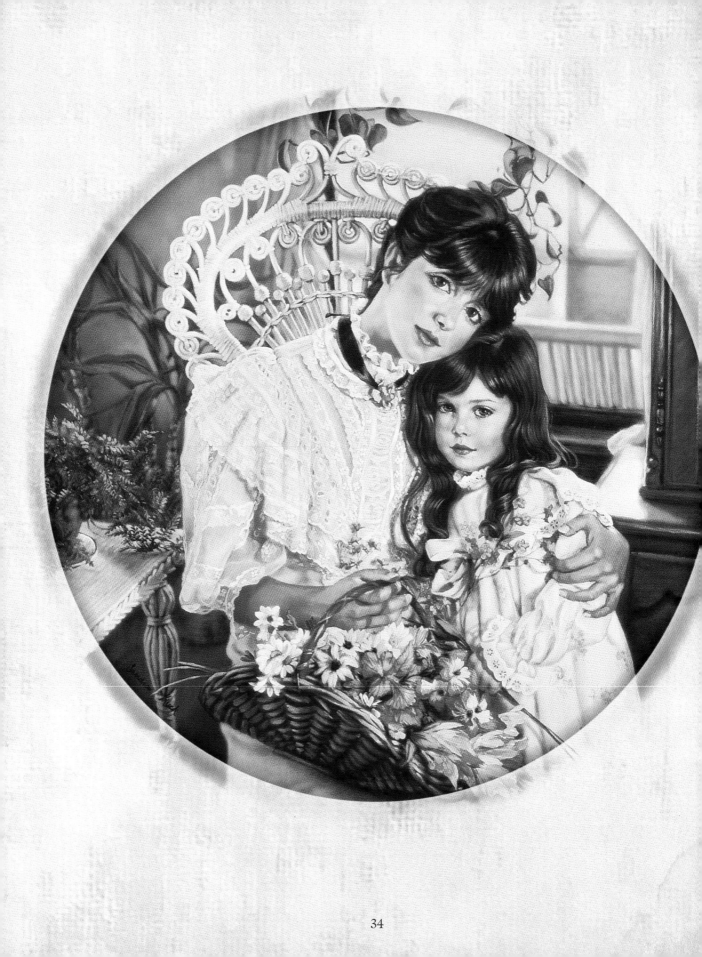

When I Grow Up

Will I be like you when I grow up?

I want to know.

Will I share more than your dark curls?

Will I—could I—also have a heart like yours,

A gentle heart

A mother's heart

The kind of heart I know from you...

A spirit that soothes

A warmth that renews

A faith that sustains

A strength that guides

A hug that encourages

A smile that empowers

May I be like you when I grow up,

loving as you love,

A living tribute to the mothering I received from you.

Dear Mom,

Hey, I know I'm not always very easy to love these days...
I know you don't always like what I'm wearing or who I'm hanging out
with. I know you wish I'd do things differently—like study more and
talk on the phone less and turn down the music and be more careful
about what I'm eating. And I know you worry when I'm driving and
when I have things due at school and when I'm out on a date.

I guess it must be hard to let go. But, you know, it's not always
easy for me either. You see, I'm letting go, too, in a way. But, Mom,
that's what you've been working for and you've done a great job. That's
why I can make my own decisions and look at different options for my
life—because you've done a great job getting me ready.

So I don't mean to be hard to love. And I don't like it when we
don't get along, when we don't agree on things. But I'm glad—even
though you can't always tell—that you keep on loving me! Don't stop,
okay? Even if you can't tell, I still need you!

So thanks for all you do! And don't forget—I love ya, Mom!

Love,
Your Adolescent Child

Who's Counting?

Eighteen years....

That's 19,656 meals prepared (not counting snacks)...
More than 10,000 tooth-brushings to supervise...
Who can count how many diapers changed?...
A thousand loads of laundry done...
Carpooling that amounted to several cross-country treks...
But those aren't the statistics that speak of what you've given.

No one—most especially not you—
has kept count of...

The hugs offered
The tender words spoken
The prayers uttered
The laughter shared
The games played
The books read
The parks visited

The joyous giving of love unmeasured
You've loved as only a mother can love.

Yet You Love

Unselfishly sacrificial and unconsciously so
No tally is kept of the broken nights' sleep
No count is made of the hurts that come with
a child's growing pains
No computations of plans rearranged
to care for your children
No numbering of sacrifices made or dreams let go
And no measure of the heartache that inevitably
comes as a child grows up and away into a world
that bruises and scars

Yet you love with a perseverance that comes so naturally
With a steadiness that steadies your child
With a tenacity that at times defies explanation

A mother is a person who sees
that there are only four pieces of pie
for five persons and promptly
remarks that she's never
cared for pie.

AUTHOR UNKNOWN

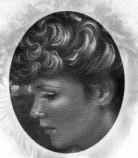

Love That Sees

Love which seems blind
as it loves unconditionally
Yet love which sees weaknesses
in order to strengthen
Love which acknowledges error
in order to correct
Love which recognizes selfishness
in order to remedy —
What a wonderful paradox
of mother-love

All Along

You offered balloons—
> But let me choose the color
> I wanted
You pointed the way—
> But let me walk the path
You dreamed for me—
> But let me pursue my
> own dreams

You have loved me with a love that
lets me be me, a love that lets me
go...
> And still you love me.
> And I love you.

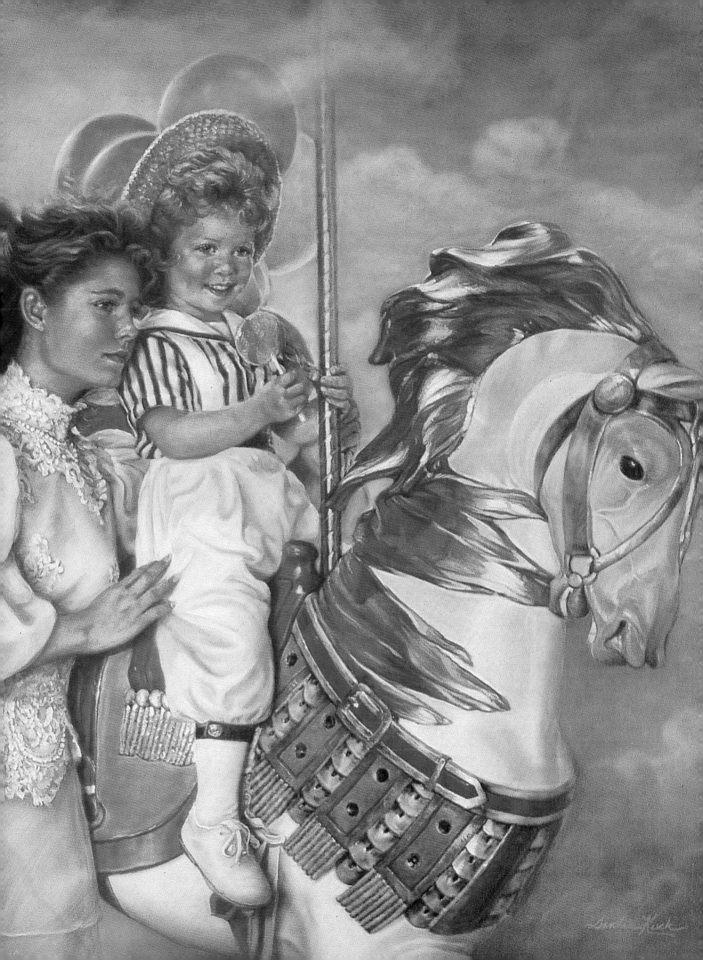

An Unquenchable Love

A mother's love...

Is drained by the midnight

feedings of an infant

The emphatic no's and constant

testing of a toddler

The new horizons of

elementary school

The peer pressure and thumping

decibels of junior high

The challenges and letting

go of adolescence

The relentlessness of parenting

A mother's love…

Is recharged with a heartfelt

smile from her child

With an unexpected hug

from her son

With a glance at her

sleeping babe,

however old he is.

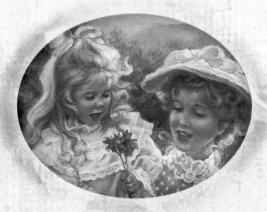

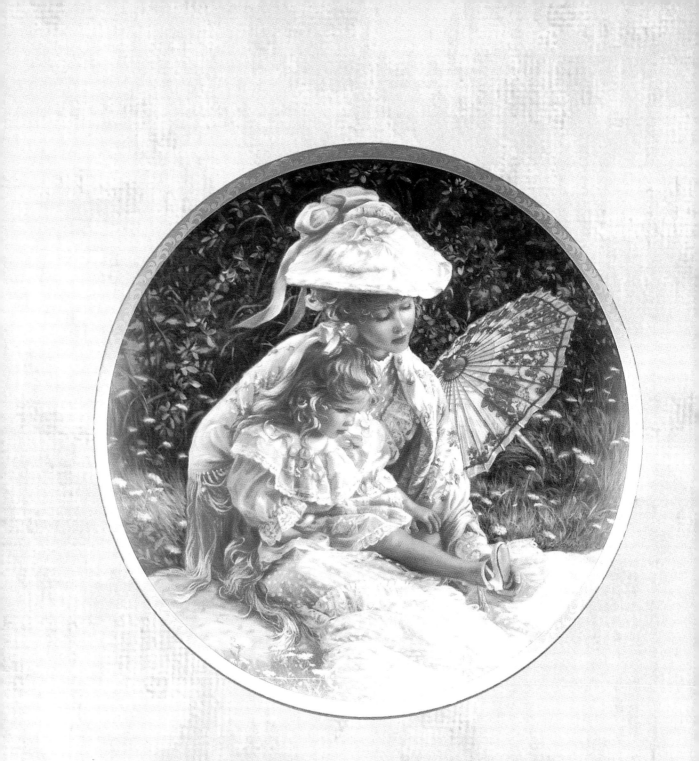

Forsake not your mother's teaching.

Bind them upon your heart always…

The Book of Proverbs

A Special Closeness

A lot to learn…A lot to teach…
Many things to hear…Many things to speak…
Much to say…Much to hear…
Things to discover…Discoveries to celebrate…
Goals to reach…Accomplishments to cherish…
Ideas to share…Thoughts to consider…
A unique perspective…A new angle and approach…

Child…Mother
Student…Teacher

Child…Mother
Teacher…Student

*To be a mother is the grandest vocation in
the world. No one being has a position of
such power and influence. She holds in her hands
the destiny of nations; for to her is necessarily
committed the making of the nation's citizens.*

HANNAH WHITALL SMITH

Holding On While Letting Go

You didn't let me get lost in the whirlwind of life —

Of brothers and sisters and their needs

Of the homemaking, money-making matters of existence

Of the fears of taking first steps, of steps away from you

You didn't let me get lost amidst the noise of growing up —

The inner turmoil of emotions and doubts, questions and fears

The clamor of friends and peers

The dictates of society and culture

You didn't let me get lost to calls from various directions —

To temptations to stray from the narrow

To lures that beckon to dangerous territory

To teasings to follow the wrong path

You've held on to me — emotionally as well as physically;

Nurturing me, growing me, letting me go—always loving me

A Child's "I Love You"

A toddler reaching as if to say, "Pick me up, please!"

A preschooler running to give a big hug

The kindergartner lingering by Mother's side

The school girl looking over her shoulder as she
heads for her classroom

The little league star winking at his biggest fan

The junior higher planting a kiss on Mom's cheek
when no one can see

The high schooler quietly talking about the boy in
her algebra class

"I love you" — sometimes unspoken,
sometimes implicit —
by children who know a mother's love.

Now...for the Future

The days of childhood
The joys of today
The hopes for tomorrow
 They all come together for a
 mother....

You loved reading to me—
 And savor the times I read to you
You prized the artwork I brought home
 from school—
 And pray about the masterpiece
 you want my life to be
You cherished the first pair of shoes—
 And celebrate where those feet
 are taking me today
You've been there for me in every
 moment of every now
 always enjoying me, loving me,
 delighting in me
 yet always pointing me toward
 the future

If we help our children to be

what they should be today,

then, when tomorrow becomes

today, they will have the

necessary courage to face

it with greater love.

MOTHER TERESA

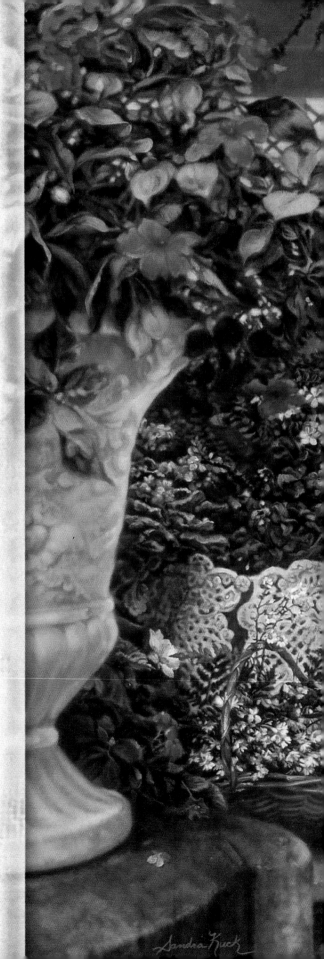

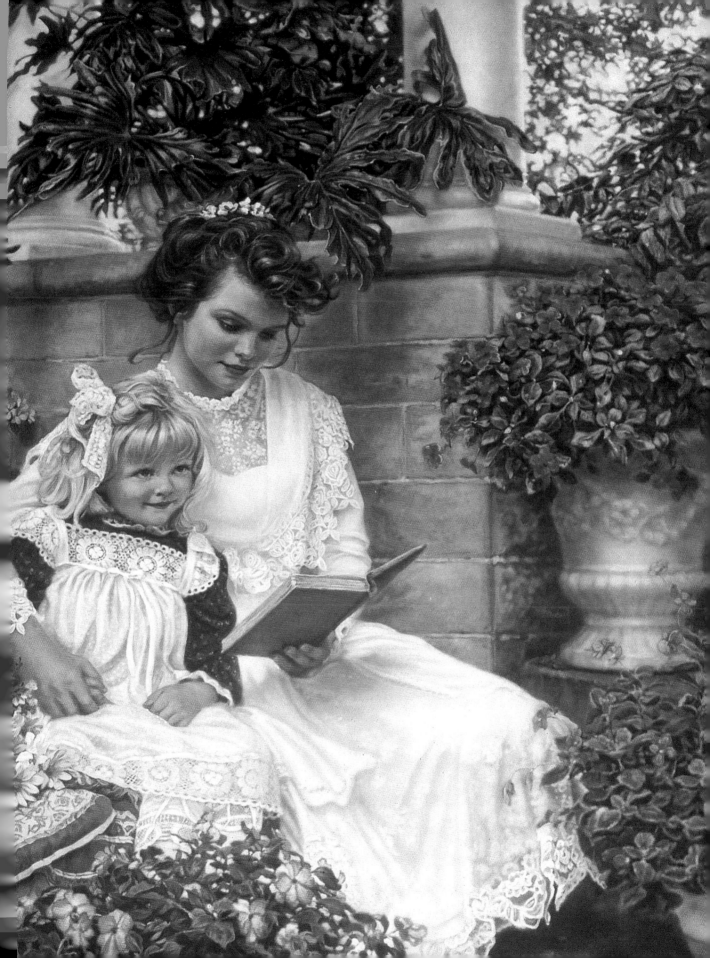

Dear Mom,

As a young child I didn't have the words to say "thank you" for all you've done. I didn't have them intellectually even had I been physically able to speak them. And now, these decades later, I still don't have the words to say "thank you" for all you've done. This time the reason is neither intellectual or physical. The reason is more one of the heart—which is overflowing with admiration and gratitude for the role you played in my life, a role I now more fully understand.

As a parent myself, I'm walking in your shoes. Oh, I don't remember the middle-of-the-night feedings I required, but now I've cared for your grandchild in the middle of the night. And I don't remember all the first steps to grade school and sports and neighborhood friendships, but now I've coached your grandchild in each of these areas and more. I do remember a little more clearly the roller-coaster ride of my own adolescence, but now the ride is even more frightening as your grandchild takes a turn.

So now, Mom, my appreciation for what you've given me is deeper and my gratitude more profound. You gave me yourself in ways I couldn't have imagined until I had the perspective of an adult and the privilege of parenting. You gave me yourself and, in doing so, you gave me, me. Your gift of life at birth became a gift of life each day as you grew me and guided me and prayed for me and let me go. Well done, I say, and thank you. Thanks, Mom, for everything. I thank you from the bottom of my heart.

Love,
Your Adult Child

Love in Action

You've taught me so much
There were the lessons spoken

· "Take turns"
· "Share with your brother"
· "Do unto others as you would have them do unto you"

And the lessons modeled

· You chose to be last as you served your family
· You went without in order that I might have more
· You loved with the kind of love you wanted us to share with others

That's mothering...

Actions speaking louder than words
Teaching me by your example what love is

A little boy's mother once told him that it is God
who makes people good. He looked up and replied,
"Yes I know it is God, but mothers help a lot."

GLEN WHEELER

What a Wonder!

Your constant giving

Your faithful love

Your servant's heart

So many things you do

go unnoticed at the time

So many things you do

go unappreciated for decades

I can only marvel at the love you've had

for me since the day I was born

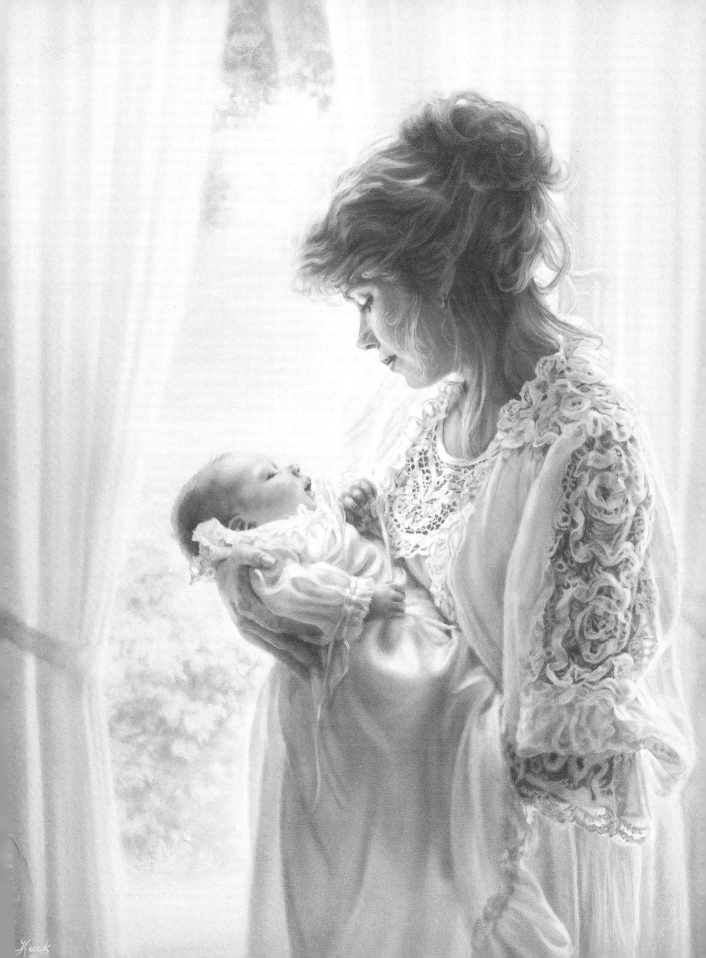

In the heavens above,

the angels, whispering
to one another,

can find, among their
burning terms of love,

none so devotional as
that of mother.

EDGAR ALLEN POE

Hello, Good-bye

You started to say good-bye the day
you met me.

As I left the sanctuary of your womb,

I was yours a little less.

And that process continues inexorably each day,
usually quite subtly, occasionally quite conspicuously.

I wander a bit farther away from you at the playground

I want to put my shoes on (backwards) all by myself

I go off to kindergarten that first day—
without glancing over my shoulder

I drive off in the car when I turn sixteen—
without a look back

I graduate from high school ... go on to college ...
tackle life on my own ... and then I look back.

What do I see? Your love woven through
my days each step of the way.

A love that is strong enough to say,

"Good-bye"

She's a Mother

She can look forever at the

Golden curls

Turned-up nose

Perfect mouth

Long eyelashes

Tiny hands

Of her sleeping child

She's a mother.

She can wonder long and hard about what her one year old is thinking

She can laugh inside at the all-too-cute but all-too-defiant two year old

She can encourage each step of the grade-school way

She can love from afar when adolescence strikes

She can embrace once again when adulthood is reached

She's a mother.

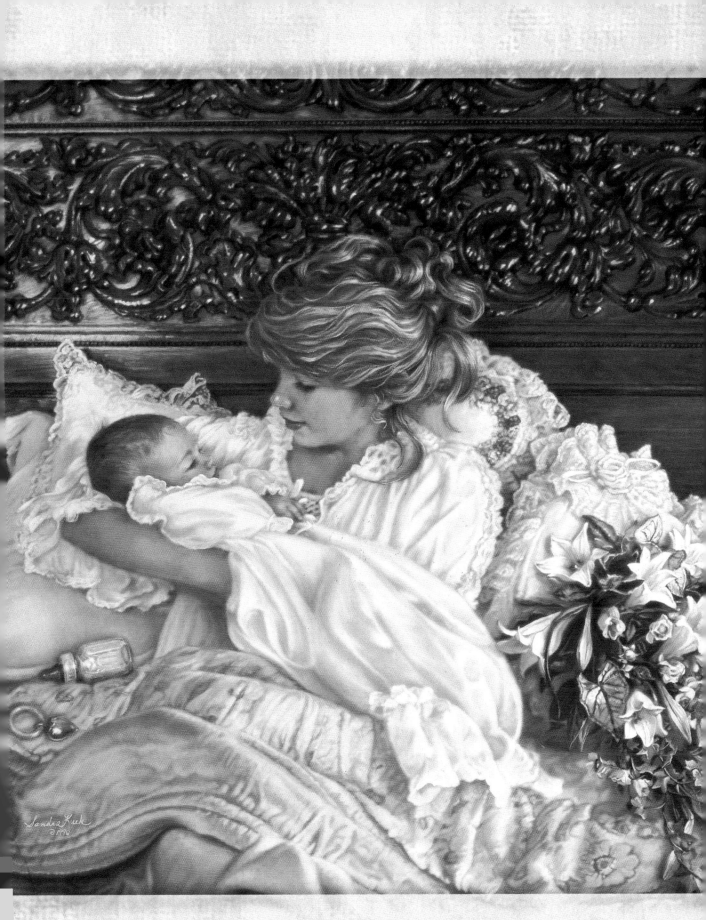

Paid in Full

It's an odd reward for a job that requires so much,
that requires everything
It's the reward of seeing your child become independent of you

It's an odd "Job well done!" for a job that's been your life,
that's known no bounds of either time or demands
It's the "Job well done!" of celebrating your child becoming an adult

But you are quick to say, "The rewards—they have been
immeasurable and constant!"
You remember the joy of first smiles, first hugs
You recall the thrill of crawling and those initial steps
You can't forget the charming first words that brought
laughter and delight
You have in your mind clear images of an infant's sleeping face, a toddler's
eyes opened wide with amazement, a preschooler's self-assured statement of
completely inaccurate facts, a third-grader's pain-filled eyes at being cho-
sen last, a middle-schooler's careful glance at you during a special moment
of sharing from the heart, a high-schooler's hesitant excitement about the
first date...
Your list goes on and on...
As only a mother can, you say confidently that you have
indeed been paid in full.

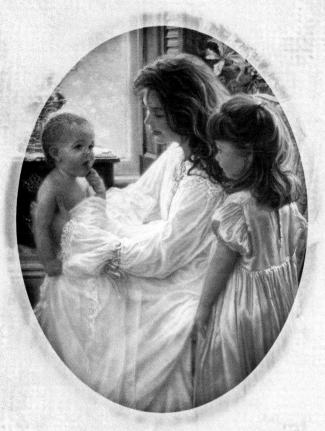

The greatest reward for our work

is not what we get paid

for it, but what we

become by it.

<small>AUTHOR UNKNOWN</small>

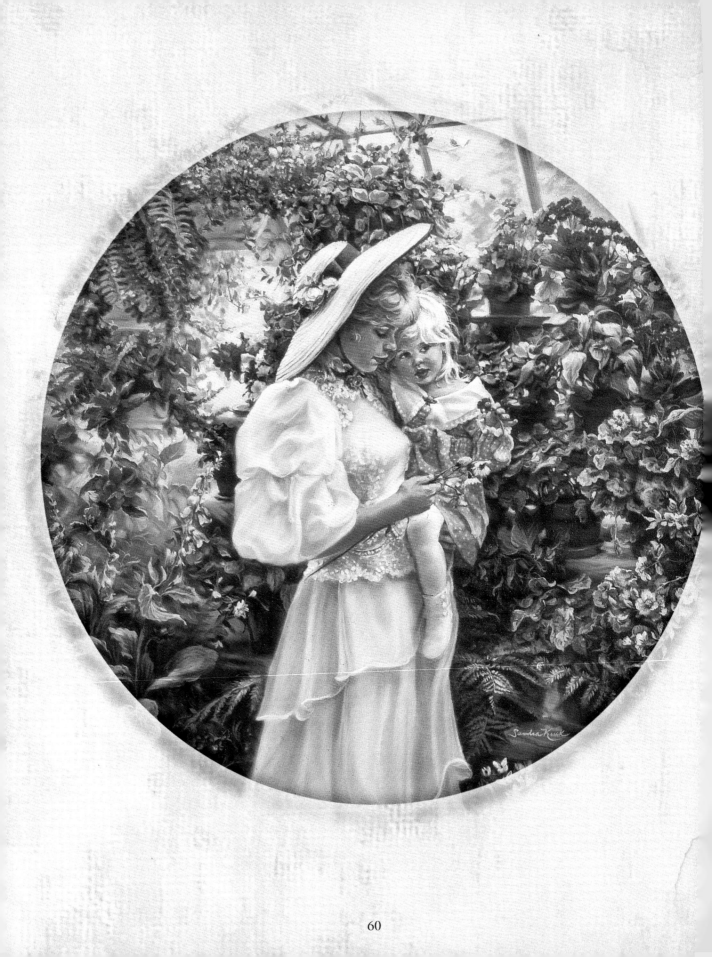

A Mother's Gardening

Your love kept my heart soft,
ready to receive what you carefully,
prayerfully planted

You sowed seeds of wisdom and guidance,
seeds that bore the fruit of maturity and confidence

You pulled the weeds of character flaws
At times you watered the garden with tears
And I know you anticipated each bit of
growth with prayer

Now may you celebrate and enjoy the fruit of your efforts
Of infant become companion
Of child become friend

No Way to Repay

You've encouraged me at my lowest points...

You've challenged me and believed in me...

You've celebrated after the successes
and comforted after the defeats....

You've prayed for me...

You've given with unlimited generosity...

You've loved me when I haven't loved myself...

You've shown me a mother's love in countless ways.

And, I suppose, like any well-mothered child,
I can do nothing to fully repay you.
But I do I give you my love,
and I thank God for your presence in my life!

The Blessings of a Dream Come True

You had long dreamed of being a mother
You longed for the privilege
Yearned for the joy
Craved the wonder

I was greatly blessed by your
dream becoming reality
Enriched by your sense that
mothering is a privilege
Nurtured by the joy that we shared
Welcomed by your marveling awe

I was greatly blessed to be
one who gave you joy —
and to know great joy from you

There is an enduring tenderness in the love of a mother. . .

WASHINGTON
IRVING